BIG-TOP CIRCUS

NEIL JOHNSON

DIAL BOOKS FOR YOUNG READERS NEW YORK

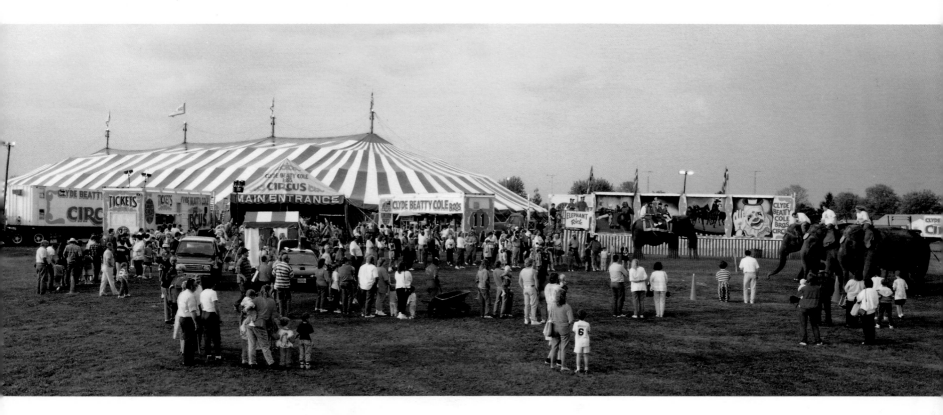

Published by Dial Books for Young Readers
A Division of Penguin Books USA Inc.
375 Hudson Street
New York, New York 10014

Design by Nancy R. Leo
Printed in Hong Kong
First Edition
1 3 5 7 9 10 8 6 4 2

Library of Congress Cataloging in Publication Data
Johnson, Neil, 1954–
Big-top circus / Neil Johnson
p. cm.
ISBN 0-8037-1602-8. — ISBN 0-8037-1603-6
1. Circus—United States—Juvenile literature.
2. Clyde Beatty–Cole Bros. Circus—Juvenile literature.
[1. Circus.] I. Title.
GV1803.J64 1995 791.3′0973—dc20 93-40274 CIP AC

• •

*Special thanks to the Clyde Beatty–Cole Bros. Circus family, especially Bruce Pratt; and to Lavahn Hoh,
Associate Professor of Drama at the University of Virginia, who checked the facts in this book.*

• •

*The photographs of circus posters are reproduced courtesy of Cole Bros. Circus.
Cole Bros. Circus is a registered trademark of and is used under the permission of Cole Bros. Circus, Inc.*

• •

PUBLISHER'S NOTE: *The circus acts shown in this book are performed by highly trained professionals.
Under no circumstances should readers try to attempt them on their own.*

TO
The AMAZING, the ASTOUNDING, the SCINTILLATING
MARGO
The best SISTER under the BIG TOP

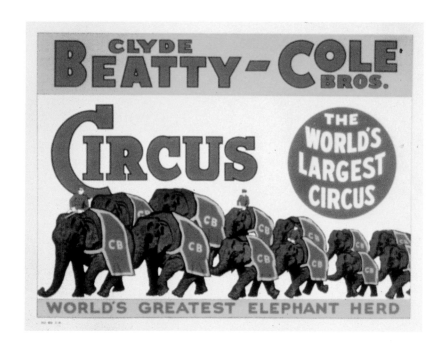

The modern circus began in England with the invention of the circus ring. In 1768 a London horseman by the name of Philip Astley discovered that if his horse cantered in a circle at a steady speed, it was easier for him to do tricks on the animal's back without falling off. A rider of Astley's, Charles Hughes, soon started his own riding show and came up with the name circus—from the Latin word for ring.

In 1785 Thomas Pool opened the first American circus riding show in Philadelphia, Pennsylvania. To the delight of the audience, a clown performed between riding acts. Then in 1793 one of Charles Hughes's students, John Bill Ricketts, opened his own American circus—also in Philadelphia—with acrobat acts as well as riding and clowning. President George Washington attended and enjoyed one of Ricketts's circus performances—and through the president's example, the new nation discovered a wonderful way to have fun.

The circus has flourished in America (and all over the world) ever since. In 1825 large tents were introduced, allowing circuses to travel and set up anywhere without worrying about weather. In America the one circus ring became three rings, and new acts—exotic animals, trapeze artists, even human cannonballs—helped the circus become extremely popular.

For many years the largest circuses always moved by train. It was expensive to transport all the performers, workers, and animals—and to run a circus. Competition and not enough money forced some circuses out of business, while others joined together.

In 1907 the Ringling Brothers Circus bought the Barnum & Bailey Circus, later renaming it the Ringling Brothers and Barnum & Bailey Circus Combined Shows. One of their star attractions was Clyde Beatty, billed as "America's Youngest and Most Fearless Wild Animal Trainer." Beatty's famous cat act featured as many as forty lions and tigers in the cage at once. He went on to form his own circus, which was merged with the Cole Brothers Circus in the 1950's.

In 1956 the "Greatest Show on Earth"—Ringling Brothers and Barnum & Bailey Circus—folded its gigantic tent and began to perform only in buildings. But today there are still many tented circuses traveling by truck from town to town throughout America, presenting circus performances under the Big Top. This is the story of what happens when one big-top circus comes to town.

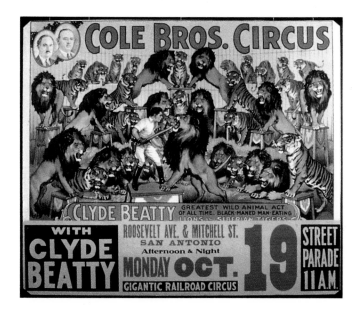

EVERYONE IN TOWN IS ASLEEP WHEN THE CIRCUS ARRIVES, its twenty-eight big trucks chuffing noisily off the highway to circle the area where the Big Top is to be unloaded and set up.

The circus rested at its winter quarters from December through March. As spring approached, the performers practiced their new acts; the trucks were freshly painted; and the new costumes were sewn. Now the circus is ready to spend the next eight months traveling to over a hundred towns and cities throughout America.

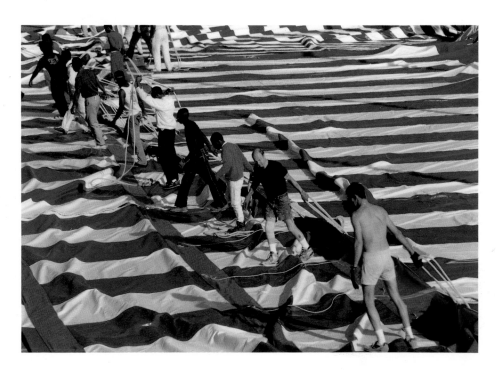

The center poles rise just as the sun comes up. The giant tent, as long as a football field, is unrolled and stretched out flat by the Big Top crew. The air is filled with a rhythmic ringing as big machines and handheld sledgehammers pound on tent stakes. Then the crew puts up the side poles all the way around the edge, and the tent is pulled slowly up the center poles.

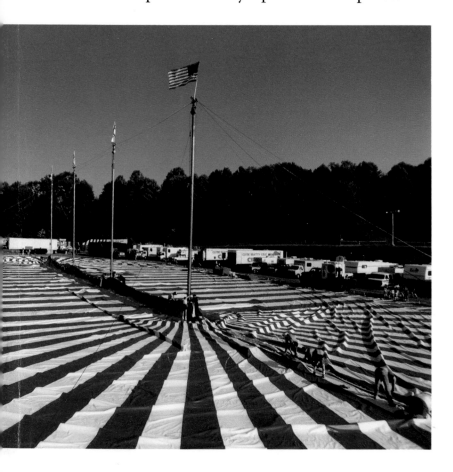

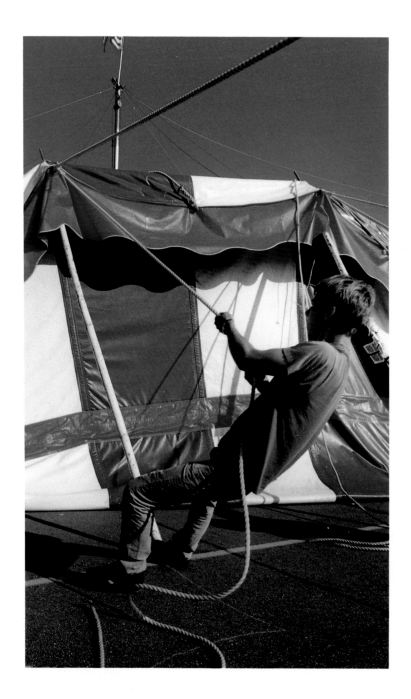

The elephants are led over to help raise the quarter poles. One end of a chain is attached to an elephant's harness; the other end is hooked to a quarter pole. These hold up the tent between the side poles and center poles.

This tent belongs to the Clyde Beatty–Cole Brothers Circus, "The World's Largest Circus Under the Big Top." A traditional tented circus like Beatty–Cole always carries its own huge tent from place to place, like a turtle that travels with its home on its back. The tent can be put up in just about any wide-open flat space.

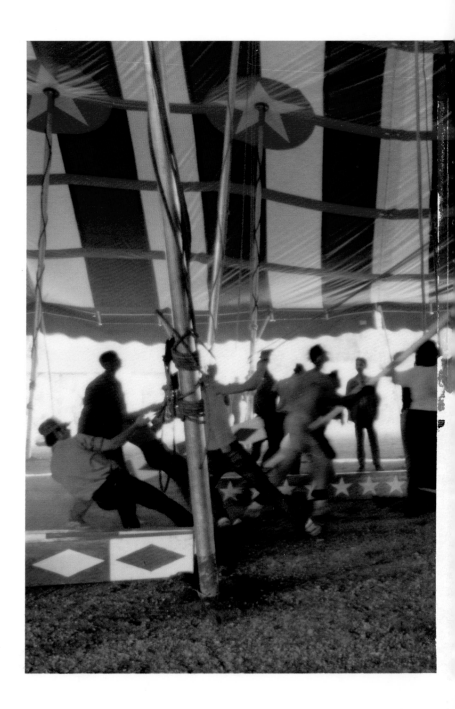

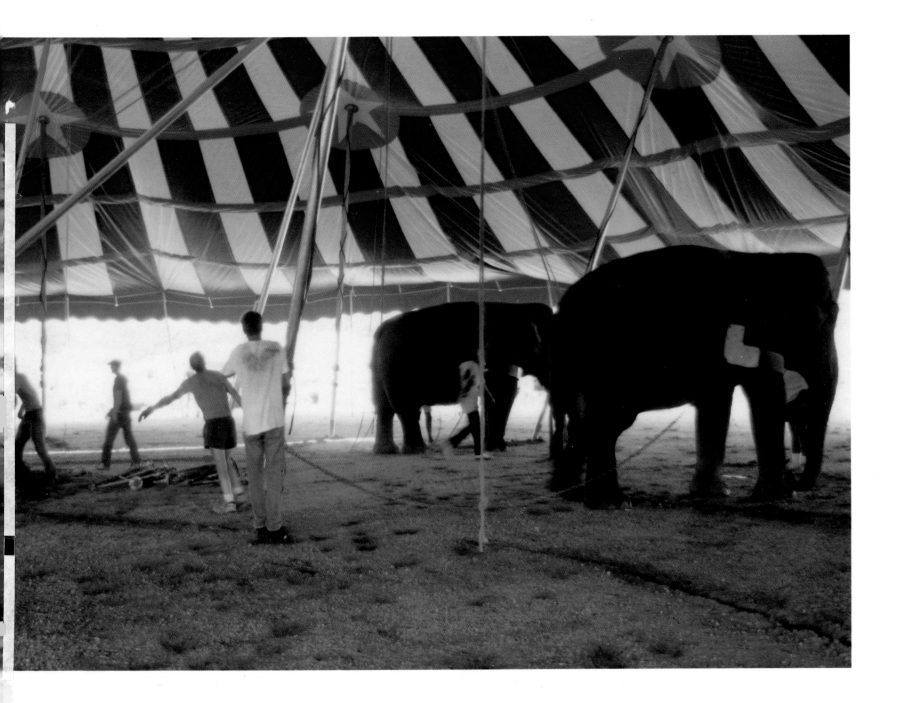

Once the Big Top is in place, there is still much more work to be done. Seats must be set up for the crowds, props unloaded, and the trapeze rigging hung from the top of the tent. A big cage must be made ready for the tigers, and two tall towers set up for the high-wire performers.

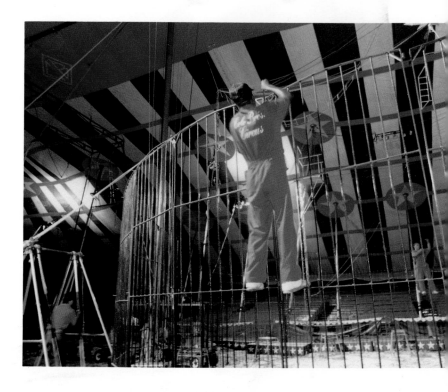

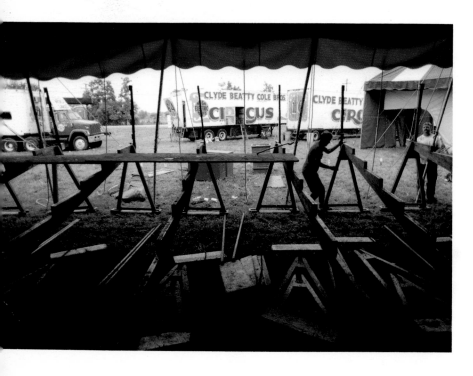

The bustle in and around the tent lasts all morning. Then the workers rest until the first performance of the day begins.

The small village of trucks and trailers surrounding the tent is called the circus *backyard*. This is where the circus family lives.

Mornings are the time the performers have to themselves. This is when they can shop, do laundry, relax, or go sightseeing.

The youngest members of the circus family, whose parents work for the circus, may end up in front of applauding crowds one day—but for now they have to study, just like kids everywhere.

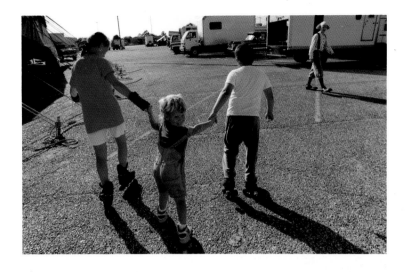

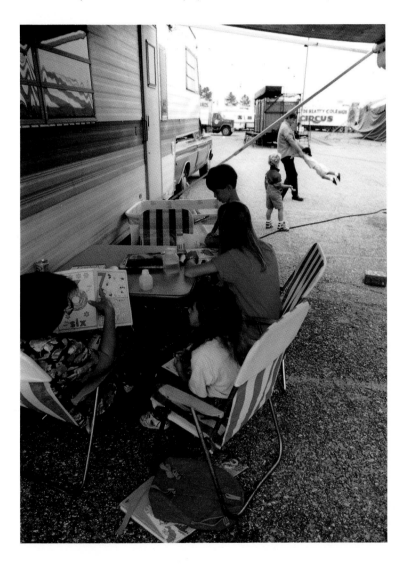

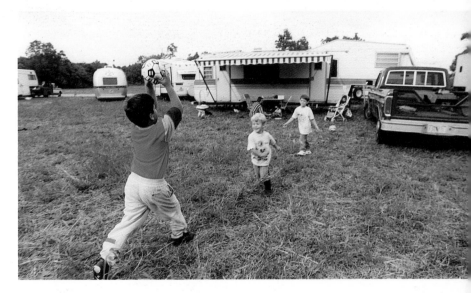

A tutor teaches them their schoolwork. After class they're free to skate or play ball among the trailers.

"Five minutes till show time!" the ringmaster announces from backstage.

The audience doesn't realize it, but they are being ushered to their seats by trapeze artists and acrobats who will soon slip out to change into their costumes. Finally the lights dim, a drum rolls, and the band launches into a lively tune. Then the lights brighten, and all eyes turn toward one end of the tent, where the performers enter in a colorful stream. It's time for the *spec*—the spectacular parade that opens the circus.

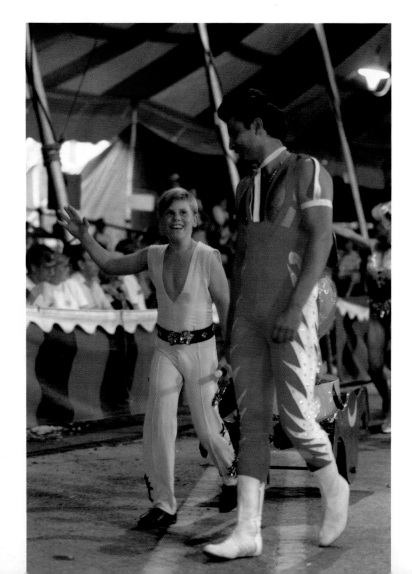

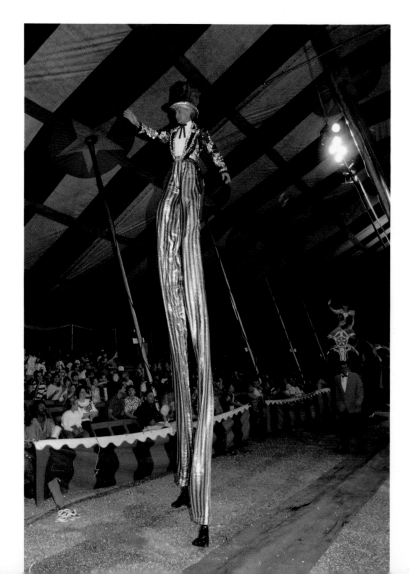

The performers march around the whole tent, their splendid costumes glittering. As soon as the last elephant plods out, it is time for the first act to begin.

Music helps set the mood for each act. The circus musicians are called *windjammers*. They play trumpets, trombones, drums, a bass guitar, and an instrument called a euphonium, which is like a small tuba. The music, fast and exciting or slow and mysterious, fills the tent from the beginning of the show to the end.

The ringmaster is the voice of the circus. He watches the show closely and keeps the nonstop flow of acts in the three rings moving quickly. His voice booms around the tent, telling the audience who is about to perform and in which ring.

"In the great tradition of America's Clyde Beatty," the ringmaster says grandly, "we now present the royal Bengal tigers in rare and exotic breeds!"

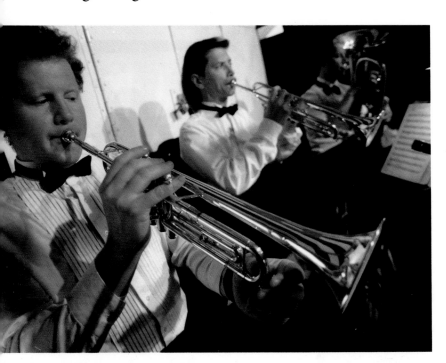

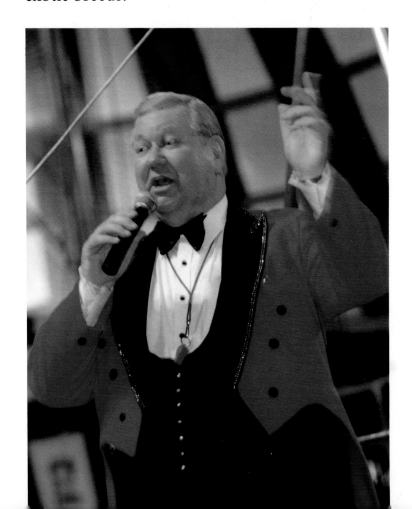

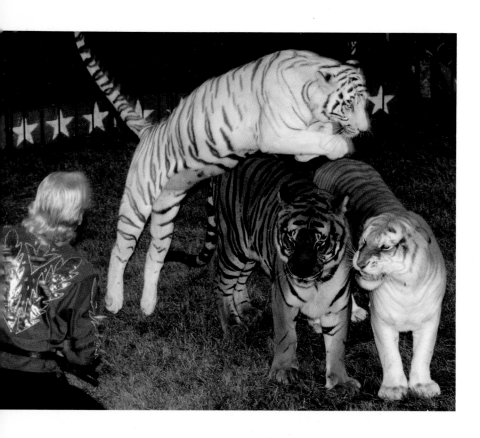

During the cat act the tigers parade majestically in a circle around their cage, then jump over one another and sit up. One gives the trainer a big hug.

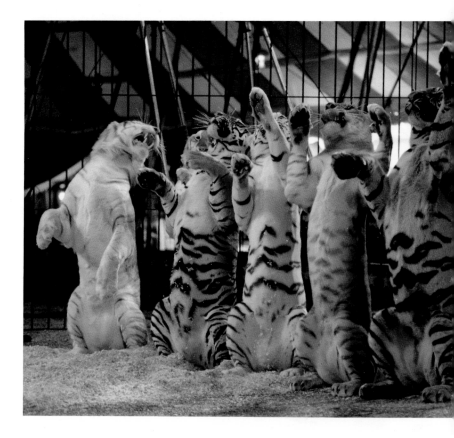

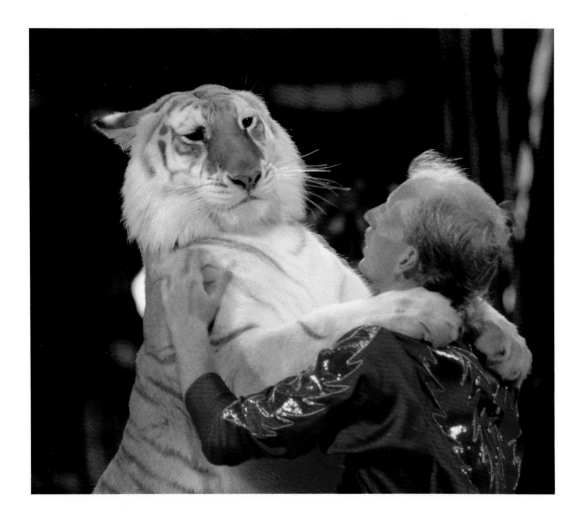

 This circus has ten tigers, including some rare white tigers and even a few *ligers,* part lion and part tiger. All of them were born in the breeding program at Beatty–Cole's Florida winter quarters. They have never lived in the wild, and if released into the jungle, they wouldn't know how to survive.

 The big circus cats are trained but not tame. They are comfortable with the few people who care for them day and night, especially the trainer who enters the big cage every day to direct their performances. But they are not pets, and they are treated with great respect!

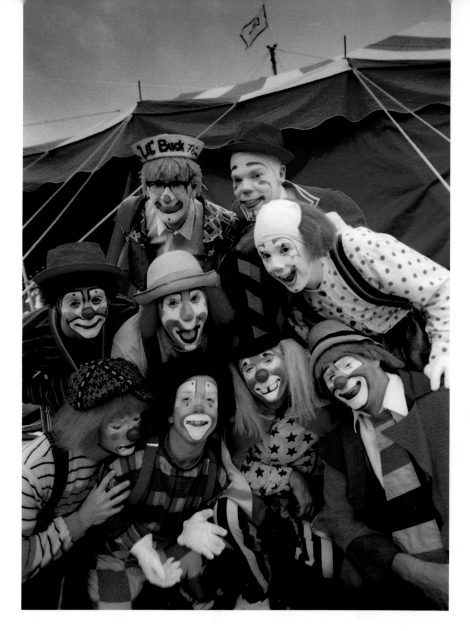

There would be no circus without clowns. They throw pies at each other, fight a pretend fire, and make people laugh in a hundred ways during each clown *walkaround*. This is when the clowns perform right in front of the audience while workers are changing the sets.

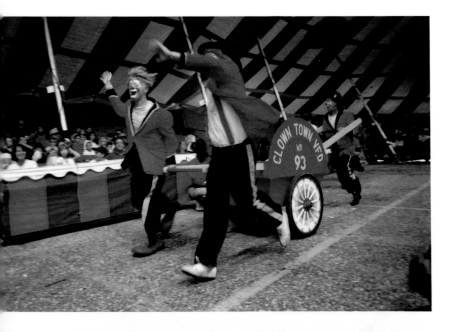

The first job of any circus clown is to choose a clown face. Happy expression or sad, blue hair or orange, big red nose or small one—every clown's face is unique.

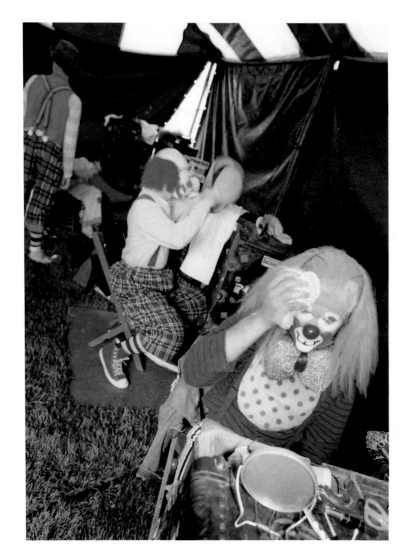

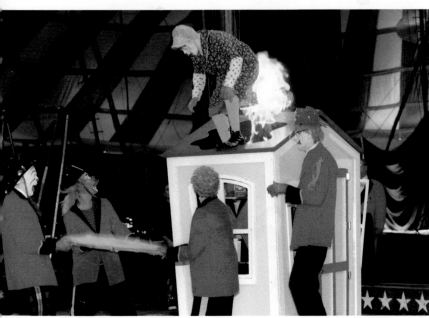

It takes years of hard work and practice to become a circus acrobat. Many acrobats have learned their skills from parents who in turn learned from *their* parents. Their job is to make the difficult tricks they perform look effortless and beautiful.

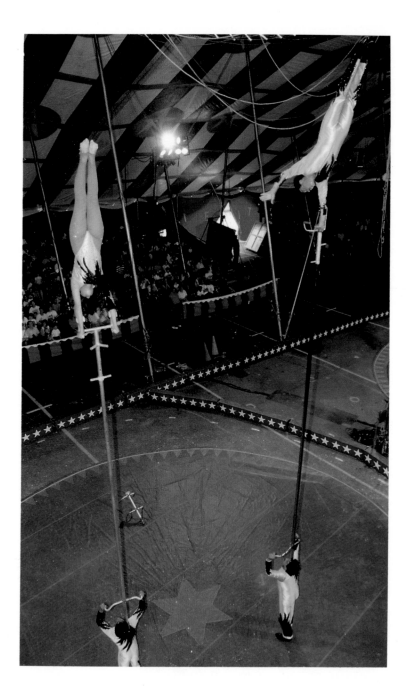

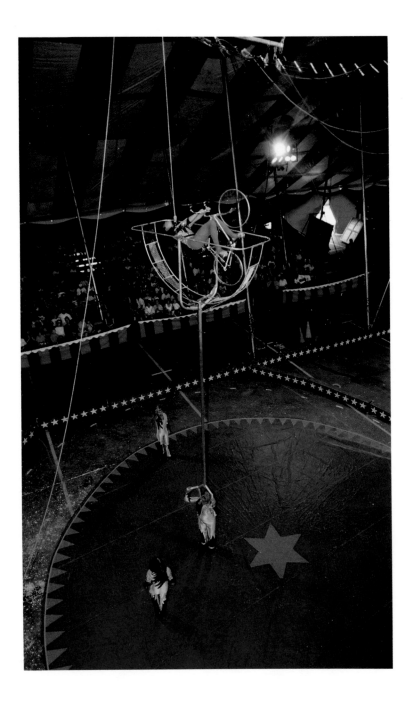

The Beatty–Cole Circus includes an acrobatic troupe that performs on a *perch pole*. One acrobat balances the pole on his shoulders while another does graceful tricks—even rides a special bicycle—way up on the top. The audience applauds the acrobat doing tricks at the top, but it is the acrobat balancing the pole who is working the hardest!

The aerial artists are acrobats who perform while hanging close to the top of the circus tent. A duo, or team of two, shows off the *cradle* act. A man hanging upside down holds the aerial cradle with his head while his partner spins rapidly below. They make it look easy— and fun!

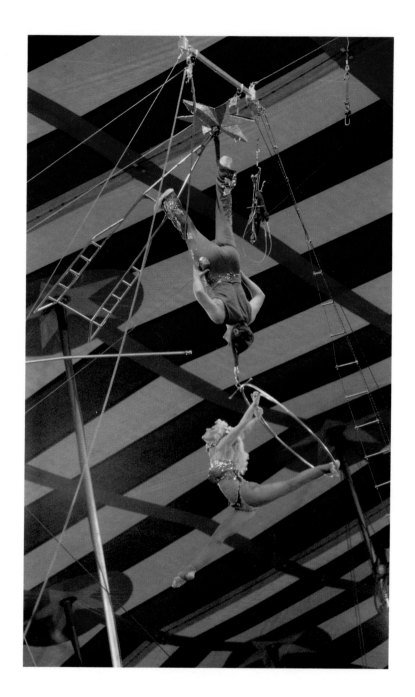

Just before her act this aerial artist soaked her hair in very hot water. The heat and moisture of the water help make her hair strong enough to support her weight in the hair-suspension act. She gracefully juggles first brightly colored rings and then lit torches—all while hanging by her hair!

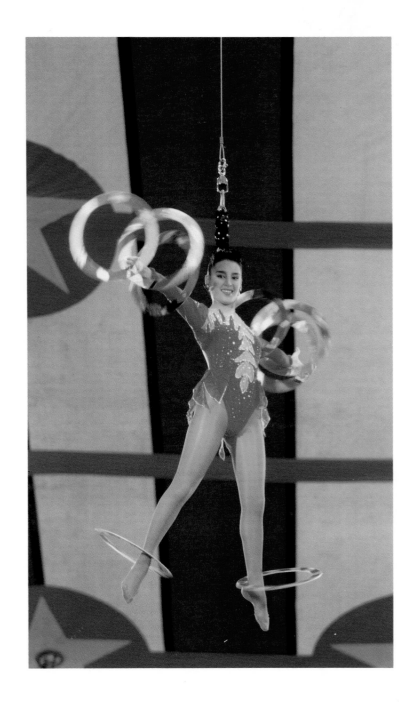

During intermission, clowns sign autographs. Elephants give rides around one of the rings. The acrobats rest or warm up for the second act. One stretches his muscles on a tent rope to make his body more flexible.

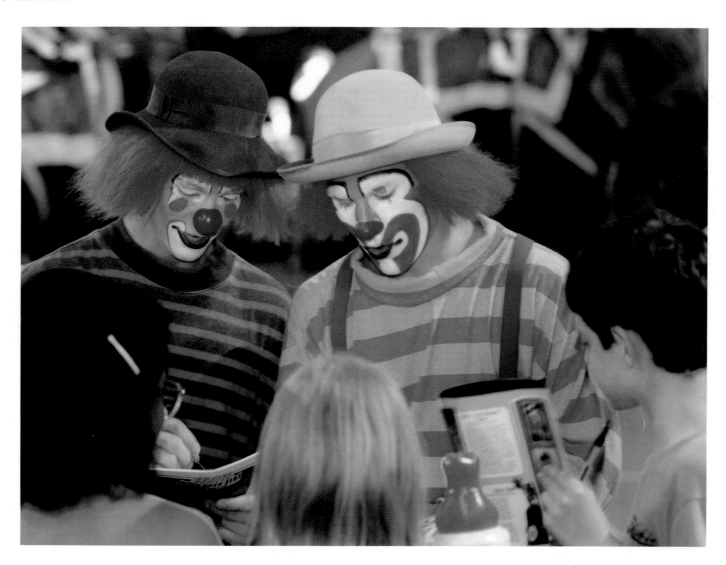

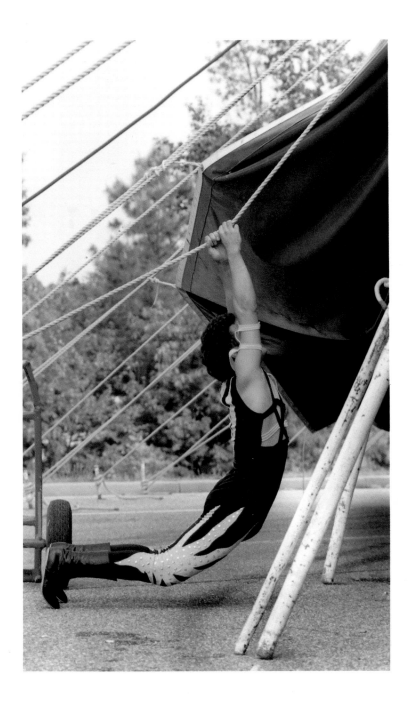

But a circus is much more than its performers, and many of its members are hard at work now. The prop crew is readying the net to be used during the trapeze act in the second half of the program, and the *butchers*—people who sell soft drinks, snacks, and souvenirs—are at their busiest.

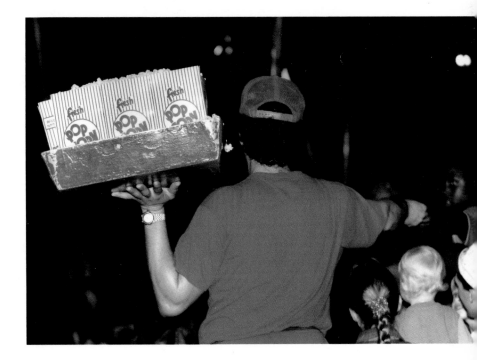

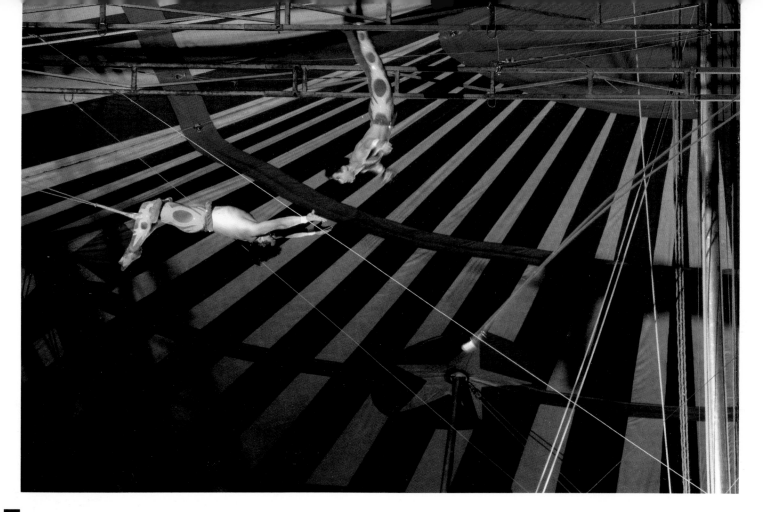

The flying trapeze does not fly—it swings. It is the acrobats who fly.

The *catcher* on the shorter trapeze kicks hard and lets his body slip down until his legs wrap around the trapeze. He reaches out his arms. Across the tent, up on a high platform, the other flyers watch the catcher's rhythm closely. At exactly the right moment one flyer grips the trapeze, jumps up high, and swings out hard. Back he swings and out again. The drum rolls.

On the second swing out the trapeze artist lets go of the bar and catapults high into the air, end over end. For one thrilling moment he is soaring in flight near the top of the tent. At the last second he reaches out for the waiting grasp of the catcher.

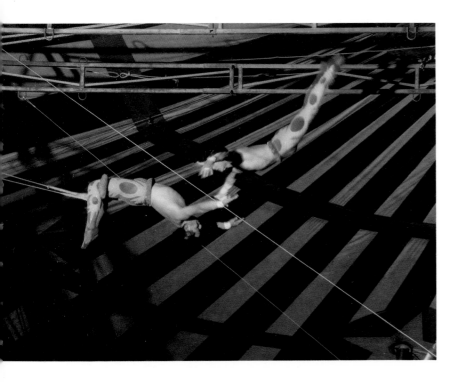

If he misses—and sometimes the flyers do—
the rope net far below will catch him. But
this time he is swung safely back to his own
trapeze, and he hops back onto the platform
triumphantly.

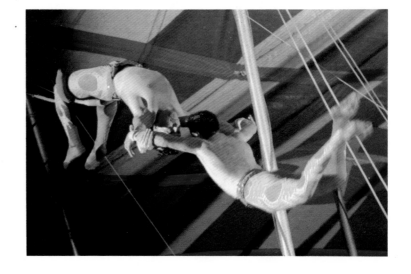

Horses have been a part of the circus since the days of the first circus ring. Beatty–Cole has *liberty* horses, trained to do tricks without riders. At their trainer's command they race around the ring and dance, then prance across the ring on their hind legs.

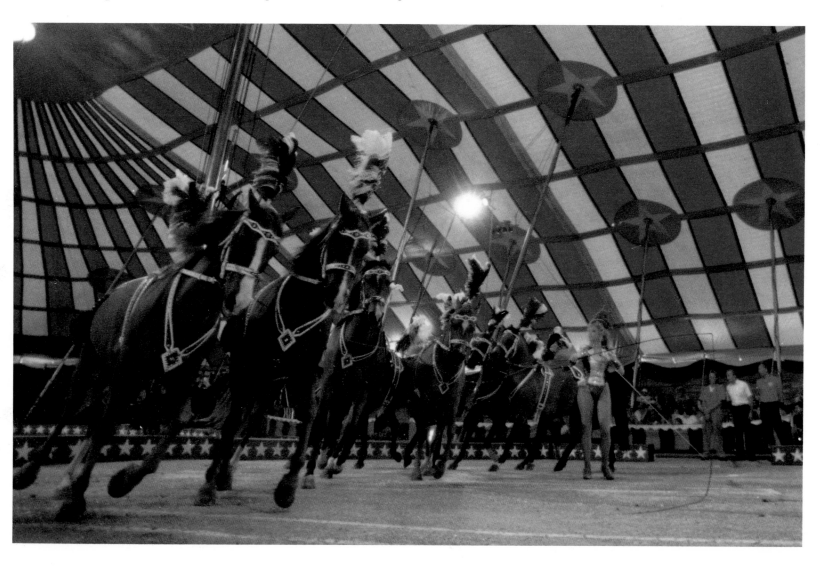

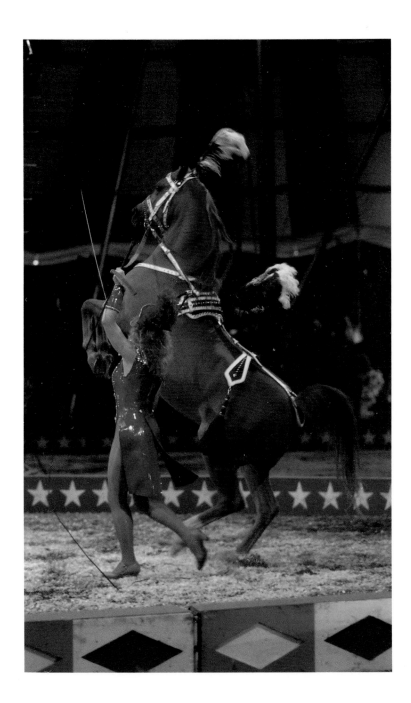

When some people see circus bears, elephants, or tigers perform, they wonder if the animals would be happier living in the wild. The Beatty–Cole animals—all of them born in captivity—are well cared for by their trainers. And the sad fact is that the natural habitats of some of these animals are rapidly disappearing. Along with game parks and zoos, circuses can actually help endangered animals such as tigers and elephants to survive through captive breeding programs.

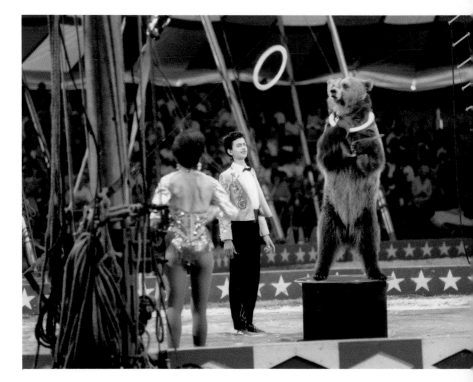

Way up near the top of the tent a metal cable less than an inch wide stretches tightly between two thin towers. No net protects the people who perform up there in the world of the high wire, or tightrope as it used to be called when it was made of rope.

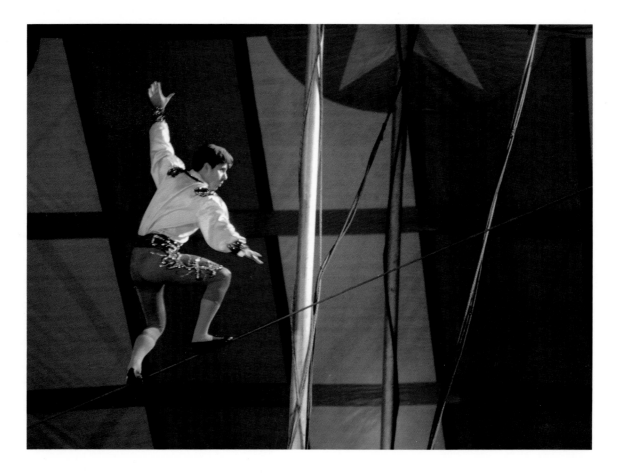

One performer climbs to the tower perch by walking up another cable. Will he make it? Near the top he slips! The audience gasps. But he quickly regains his balance and steps up to the platform with a flourish. Everyone applauds when they realize he had only pretended to slip.

There is nothing fake about the high-wire act. This special kind of acrobat needs courage, concentration, patience, and a finely tuned sense of balance. Some high-wire performers use a long pole to help with their balance, but others use nothing but their arms as they dance or even jump rope high above the crowd.

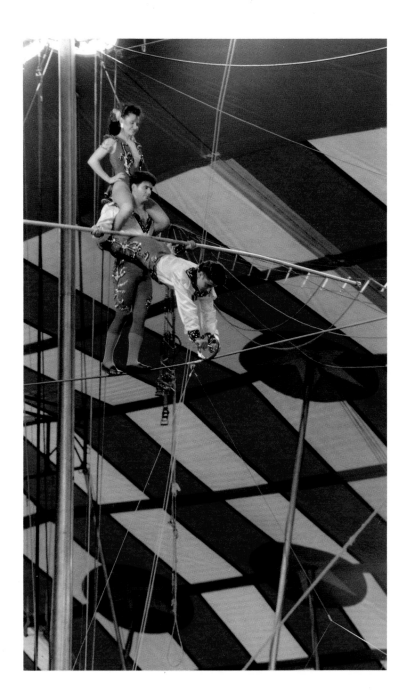

Finally it is time for the elephants. They are the kings of the circus—or in this case the queens, for Beatty–Cole's entire herd of Asian elephants are females.

In they come, thirty tons of trained animals running at a surprising speed for such gigantic beasts. They twirl this way and that, sit up with front feet and trunks high, and bow to each side of the tent.

Then each elephant rises up on its back feet, towering over the trainer and assistants, and puts its front feet on the back of the one ahead. It is time to lumber out of the tent in the elephant *long mount*.

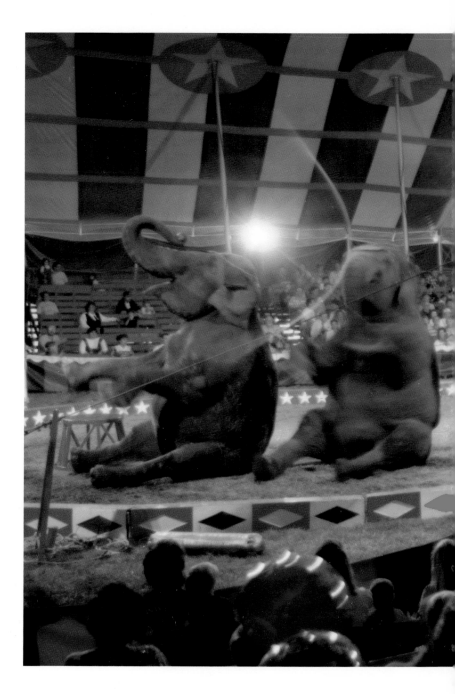

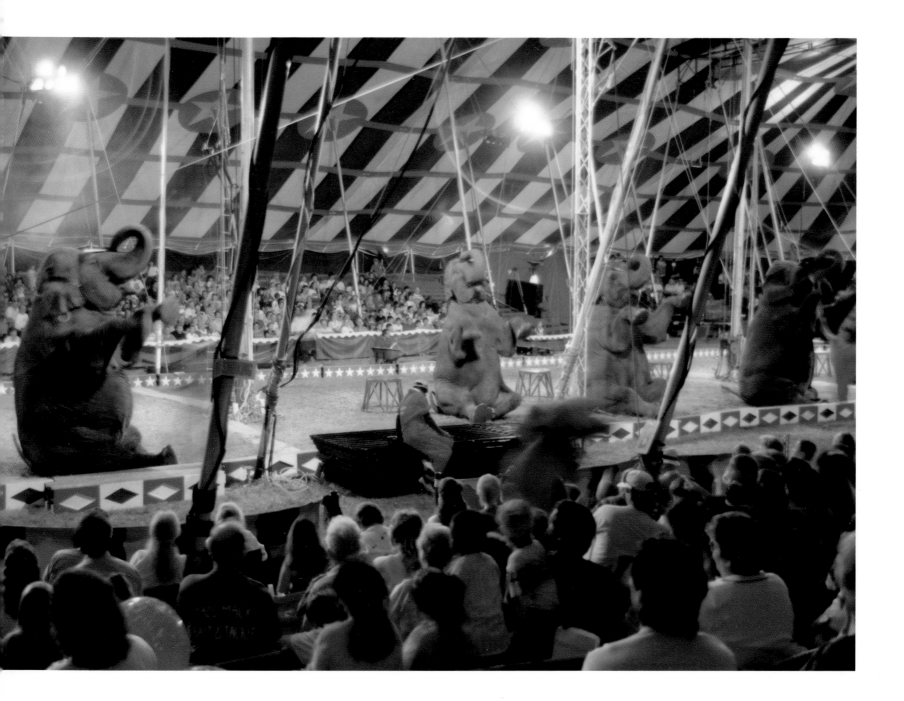

The circus will stay in town for two or three days. After the last show the workers will strike the tent, and the traveling circus family will move on to the next town.

Then there will be only trampled grass or a parking lot where the Big Top once stood. But next year the circus will return with its brassy music, its musty smell of elephants and tigers, its tastes of popcorn and cotton candy, its swirling color and pageantry, its silly clowns and daring acrobats. And once again the audience will be welcomed into the warm glow under the Big Top.

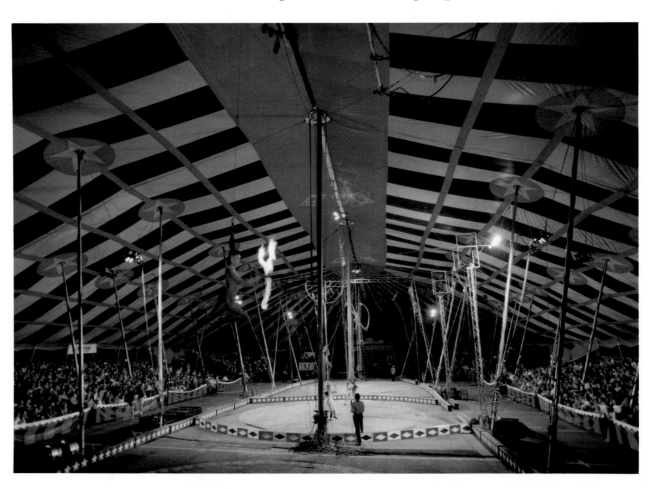